GRAPHIC DESIGN

IN THE COMPUTER AGE

General Editor: André Jute

VIDEOGRAPHICS

by
Hugh Skinner

design for
the small screen

Batsford

Credits

No multimedia project can be created in isolation.
Partners, designers and programmers at EPCo,
clients, their designers, copy-writers and artists,
teachers, subject and learning design experts,
software writers, computer techies, testers,
all contributed to the final results
and share the credit.
Thank you all.

ISBN 0 7134 7401 7
A CIP catalogue record
for this book is available
from the British Library

Jacket design
by André Jute.
Illustrations
by Gill and Hugh Skinner.
Interior design
by Hugh Skinner.

Typeset and originated by
Dublin Online Typographical Services, Dublin.

Printed in Singapore for the publisher
B. T. Batsford Ltd
4 Fitzhardinge Street
London W1H 0AH

Videographics

A production for the television or computer screen where the emphasis is on still or animated graphics, rather than full motion video.

An art form in its own right.

The Opportunities

Digital videographics offers marvellous opportunities to young computer-literate designers with aural as well as visual leanings and a generalist approach to their work.
Imagination, flexibility and a fresh approach are essential attributes.

Everything we do is new and there is as yet no clear grammar.

The Challenge

Traditional video has over the years evolved a language and grammar of its own.

Videographics is only just learning to speak.
The challenge is here.

Contents Map

Most non-fiction books are still linear. Written to be read from beginning to end. But few are read this way, with the possible exception of those concerned with history.

Before we get to the regimentation of the page numbering system, let us be clear that this is a book for dipping - a string of thoughts and examples linked and connected by many different strands.

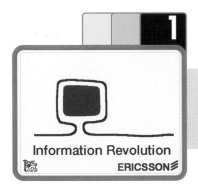

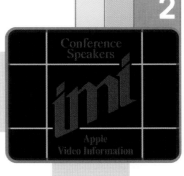

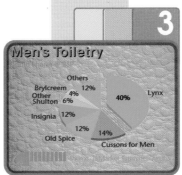

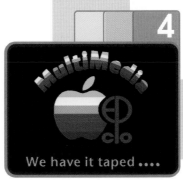

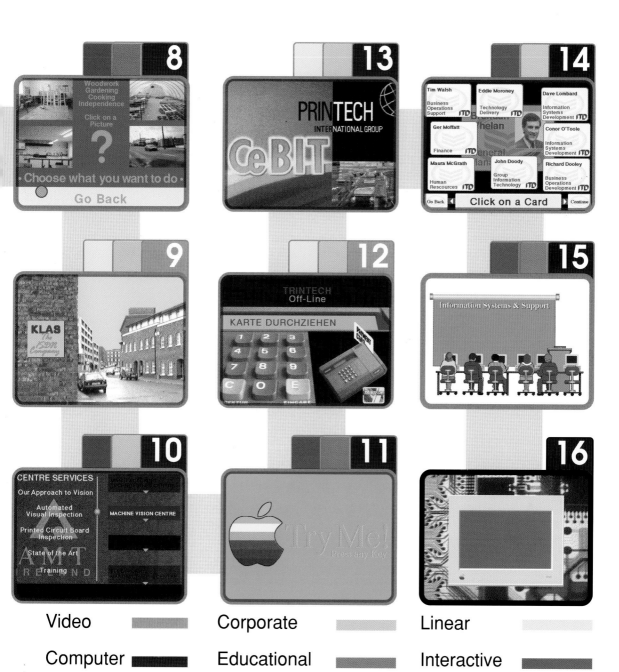

Video ■■■ Corporate ■■■ Linear ■■■

Computer ■■■ Educational ■■■ Interactive ■■■

But since we are confined to paper, bound in numeric sequence, you will find a Contents Map at the beginning and an Index at the back.

The main limitation on using this book is the number of digits on the human hand which can be inserted in the required pages - without dropping the book!

Videographics

Videographics have existed on a limited
scale in broadcast TV in the
area of titling, still screens
showing sports results or the
weather, and as a facet of some pop videos.

They began to develop when graphic computers such as the Apple
Macintosh were used for creating slide shows in digital format.

Once the ability to digitise sound, control timing and insert
transitions between graphics became available on a range of output
devices, the scene was set for the development of Videographics.

An understanding of videophotography and sound are necessary
additional skills, but the art of composition is still central to the
design process though that skill now needs to be extended to the
whole production over time, as well as to individual frames.

As in all design work, the originator must understand the medium
used to create the work as well as that in which it is to be delivered.

7

Analogue to Digital

The translation from analogue to digital media which has allowed this development is best explained by describing the differences between the two.

Analogue media: film, tape, disk, paper: sub-divided into 35 mm, VHS/Beta Hi-8 Hiband U-matic **S**VHS, vinyl video or optical disk audio/video tape, treated or plain paper, continuous film or slides, amongst others.
Most are incompatible and mixing or editing them is usually a physical task demanding expensive equipment and considerable skill to overcome the problems of different standards and material.

Digital is the language that computers use, expressed in the on/off state of an electrical circuit.
Once different analogue signals have been converted to digital, creating and editing different combinations is hugely simplified and the designer can concentrate on the end product.
Once the material exists in digital form on a computer it can be output to many devices and in many forms.

Furthermore, digital media are easily transmitted and can be sent and received quickly, accurately and without degradation.

Analogue degrades with transmission and reproduction.

Digital is a faithful original, easily manipulated by a computer.

Client	Corporate - L.M.Ericsson
Type	Public Lecture
Colour	256 System
Delivery	RGB Projector
Length	One hour

The Lecturer's Project

Slides commissioned in 1988 to accompany the
bi-annual George Boole Memorial Lecture.

A major presentation held in Ireland's National Concert Hall
to celebrate one of the countries most famous mathematicians, the
father of Boolean Logic, the basis of much computer programming.

It was therefore especially apt that L. M. Ericsson,
the international telecommunications company, should stipulate
that their presentation use computer-generated graphics.
Copywriting, posters and ticket design were carried out by EPCo.

A project which predates animation software but used Powerpoint slides sent direct to screen, and took advantage of the speedy transition between slides to create transition effects and apparent animation.

Careful positioning of text around a strong fixed graphic and the by-line created a flowing introduction, moving the visual emphasis from diagonal to centred.

Animations were created on a slide-by -slide basis and flicked through using the equivalent of the schoolboy's notebook technique.

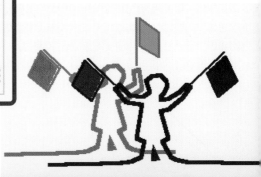

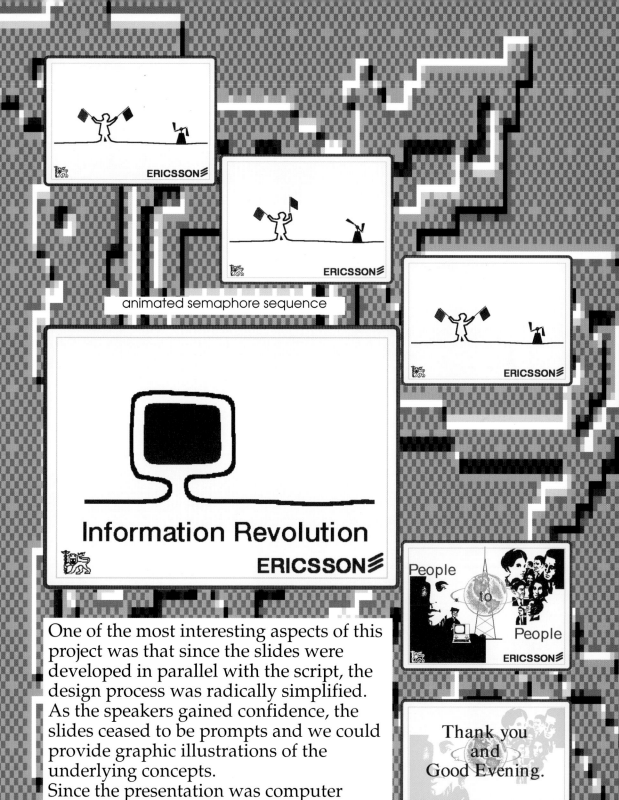

animated semaphore sequence

Information Revolution

ERICSSON

People to People

ERICSSON

Thank you and Good Evening.

ERICSSON

One of the most interesting aspects of this project was that since the slides were developed in parallel with the script, the design process was radically simplified. As the speakers gained confidence, the slides ceased to be prompts and we could provide graphic illustrations of the underlying concepts.

Since the presentation was computer based, this presented very few problems.

Design

Design is about ideas,
alternative ways of doing things,
looking at things from new viewpoints.

Design is about communicating.

Design is about problem solving,
with a strong emphasis on the visual element.

External form, shape and colour communicate.
The steamroller and the Porsche are both mainly metal
and to be driven but as soon as we look at them we know
instinctively that their functions are different.

To quote the words of an early architect:
"Firmness, Commodity and Delight".
Or of a more modern designer:
"Form follows Function"

and the Designer

A good designer understands the Subject, the Medium and the
Object(ive) and works best when these are clear.

The subject needs to be clearly defined at the briefing stage and
therefore good storyboarding is a key activity.

The medium is decided by brief, storyboard, output device and the
nature of the target audience (unaware/interested/naive).

The object (education/entertainment/information).

For a mutually successful outcome, deal with a single
client representative or as small a group as possible.

Client	Corporate - Apple / IMI
Type	Public Information
Colour	256 System
Delivery	Composite Video
Length	Continuous

The Conference Project

The Irish Management Institute Conference in Killarney attracts international corporate heads and senior politicians.

During a period when Apple were a major sponsor, Electric Paper Company designed and produced a daily Conference Newsletter using Desktop Publishing technology which was printed and delivered to delegates at their hotels before the earliest riser even awoke.

In 1989 we suggested that it would be appropriate to demonstrate the powers of the new concept of multimedia and decided to create a number of point-of-information booths in the conference hotel lobbies and main hall.

The decision was taken to modularize the design, with a strong visual link capable of pulling all these pieces of information together .

dissolve in

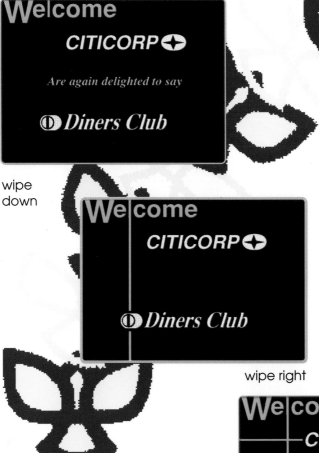

wipe down

wipe right

A later addition was a computer based booth in the main conference hall displaying tourist attractions in the adjacent area and capable of being updated with instant messages.

The animated bird is based on the Great Southern Hotels Logo

diss

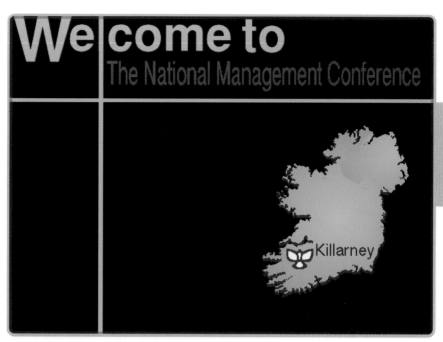

We|come to
The National Management Conference

Killarney

The bird flies to the conference
location and settles, its final form
being the logo of the Hotel Group
hosting the IMI Conference

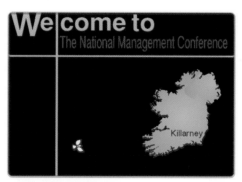

animate bird

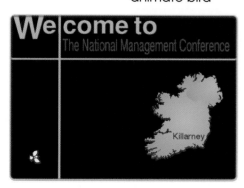

e in

The final solution was to use a
design with a sectored screen,
allowing a multiplicity of shapes
and spaces which coped with the
anticipated as well as the unforeseen
problems remarkably well.

NEW WAYS FOR THE *Nineties*

CONFERENCE
NEWSLETTER

The design had to allow for a striking opening sequence, introducing the main sponsors and animating the conference theme graphics used on the newsletter and all conference literature.

It also had to introduce and accommodate the organizer's logo and a series of sponsors' logos.

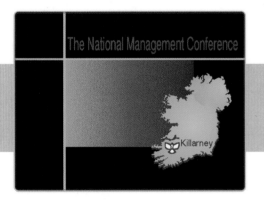

Computer generated sound patterns are decorative in their own right

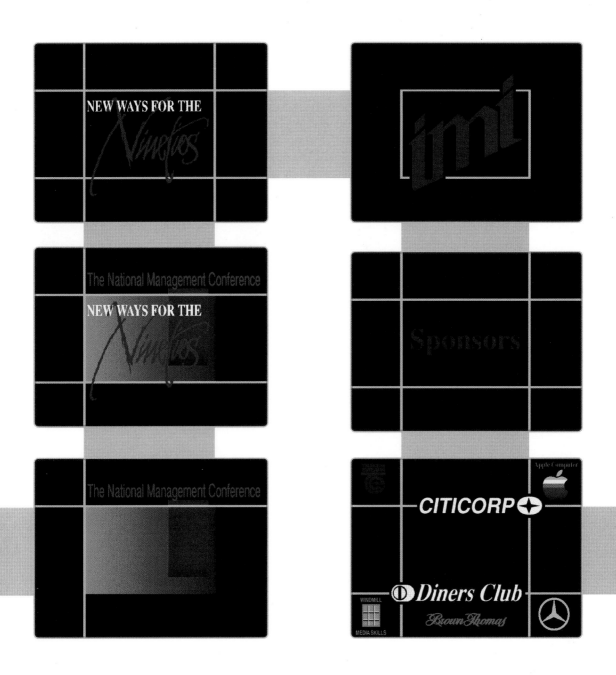

The background music was "Morning" by Edward Grieg, suitably classical and upmarket but probably lost on early rising delegates or late night revellers. Two of the Hotel lobbies had Muzak, consequently we had to turn our sound off. A lesson here:- do remember to check your output location for external and internal lighting, sound etc. as part of your briefing procedures.

Later screens had to display programme and speaker information for the day and make provision for information updates as the conference progressed.

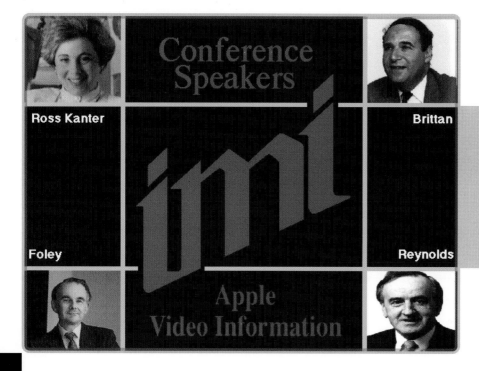

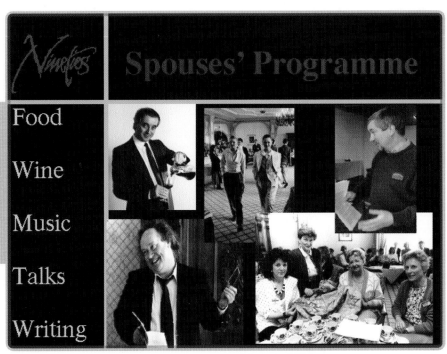

Spouses' Programme

Food

Wine

Music

Talks

Writing

Because the entire production was carried out on site, we were able to incorporate photographs taken on the same day.
In fact, the information on events was even more up to date than that in the newsletter, which still had to be sent out for printing.

P.S. This evening following your arrival you are invited to a welcoming drink and continuous buffet at this Hotel

Desktop Revolutions

Desktop publishing started it and set a standard that hardware and software manufacturers have tried to recreate.
However, for any such revolution to succeed it appears to need at least three facets - a Holy Trinity- or more aptly a Gang of Three: hardware, software and an output device.

Desktop publishing had all three at the highest level.

Hardware: - the Macintosh, a highly graphic user-friendly machine .
Software:- PageMaker, a seminal piece of software that anticipated the needs of a market that didn't even exist.
Output device:- the LaserWriter - a printer that so far outclassed previous products that most people didn't know what to do with it.

Desktop slidemaking was the next hoped-for breakthrough.
This was more of a damp squib. The hardware in the form of the Mac was there - sufficiently powerful and with excellent colour.
Slidemaking software such as Powerpoint and Persuasion was good but the slidemaking devices of the time were slow and inaccurate.

This led to the third wave - desktop video - approached with more caution and quickly submerged in the hype that became multimedia.
Nevertheless, the three ingredients were there.
The Mac was now even more powerful. Software in the shape of MacroMind Director, the PageMaker of multimedia, and for output the ubiquitous TV accessed through video cards like the NuVista, which, with its encoder/decoder, could translate Mac/RGB Video to a composite TV signal sending it to tape and/or screen.
Director was also able to control digitized sound which could be sent in parallel to the output device, setting the stage for the next major breakthrough into creating and controlling digital media.

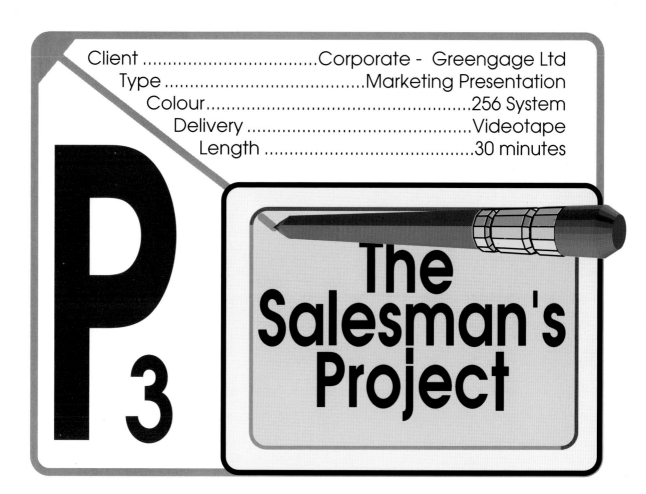

ClientCorporate - Greengage Ltd
TypeMarketing Presentation
Colour..256 System
Delivery ...Videotape
Length30 minutes

P3

The Salesman's Project

A travelling presentation made to supermarket managers
in their stores.

Much of the material was facts and trends - therefore
the show was enlivened by animation and cartooning.

Backgrounds were of obscured glass.

Colours were chosen to be cool and hygienic.

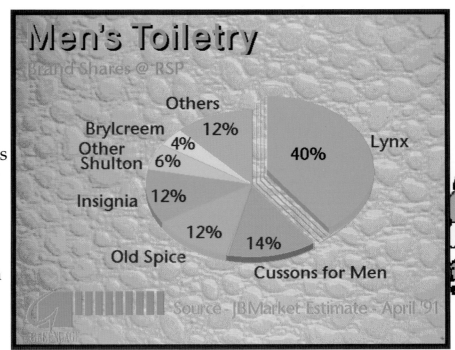

22

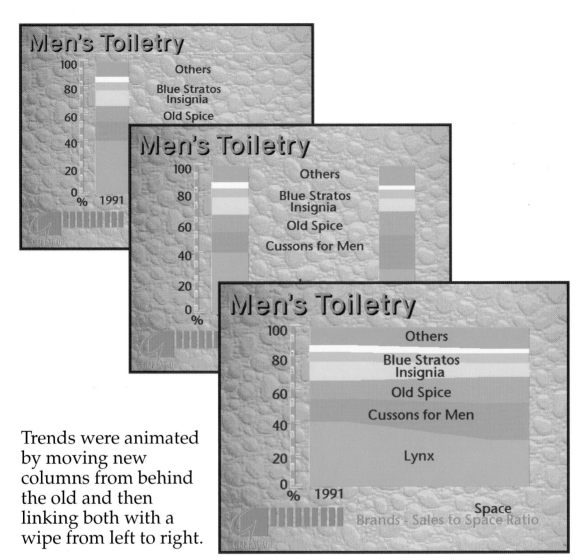

Trends were animated by moving new columns from behind the old and then linking both with a wipe from left to right.

No Universal Panacea

The computer is not the answer to all problems.

An extraordinary tool capable of being shaped to an amazing range of tasks, its very versatility can be a trap and a restriction.

Beware!
At sketch design stage it can give the wrong message to a client, saying "finished" rather than "just beginning" - fine if you get your approval but unlikely to provide a proper starting point for exploratory discussion.

Soft pencil gives a different message.

Client..Corporate - Apple
Type ..Promotional
Colour...256 System
Delivery ..Composite Video
Length ..5 seconds

P
4

The
MultiMedia
Project

At one of their many presentations on MultiMedia,
Apple decided to issue a videotape prepared in the United States
to each conference delegate.

Since Electric Paper Company were also involved in the preparation
of the presentation, we were asked to provide a localised
introduction which was edited onto the tape.

01010

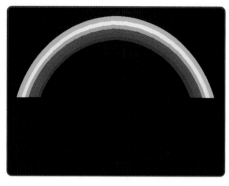

A simple recipe.

Take a rainbow made of
Apple colours,
Cut out to form the word
MultiMedia.
Roll in Apple's logo with
appropriate sound.
Wipe in a strapline and...

dissolve out

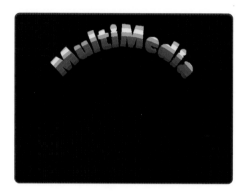

roll in Apple outline
from left
with sound

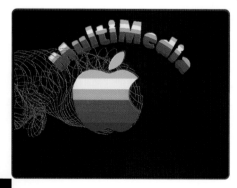

wipe right

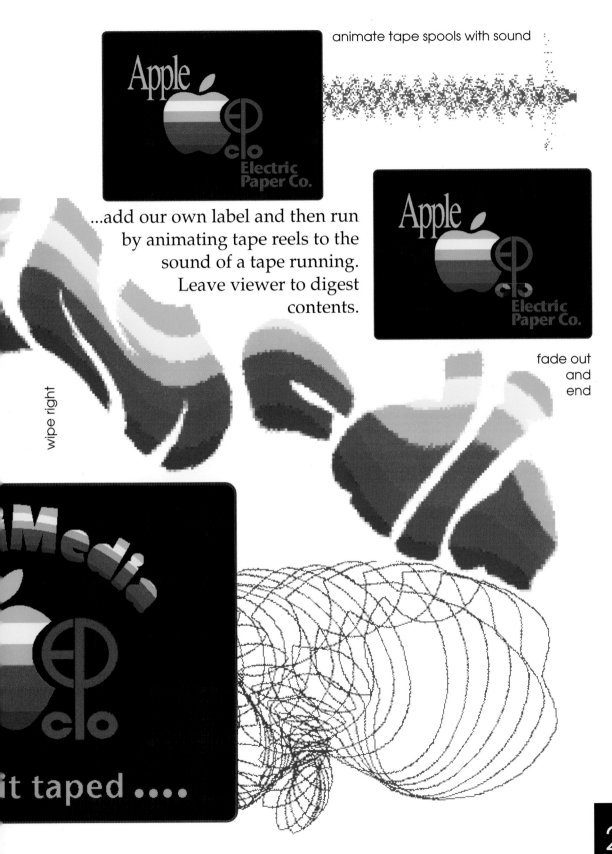

animate tape spools with sound

...add our own label and then run by animating tape reels to the sound of a tape running. Leave viewer to digest contents.

wipe right

fade out
and
end

it taped

A Multimedia Cookbook

Good milchcow and pasture, good husbands provide,

the resdue good hoswiuves knowes best how to guide".

Traditional maybe but pointing a few parallels.
Any multimedia production can be broken into two main areas:
Ingredients and preparation: Content and assembly.
It will demand a multiplicity of skills and, unless all these can be
found in one individual, team working of the highest level.

Multimedia is multiskilled.

Like cooking, a multimedia production should be sampled
at regular intervals during its preparation.
But it has one huge advantage.
The process is reversible.
You can go back,
rejig, reshape
and reform.

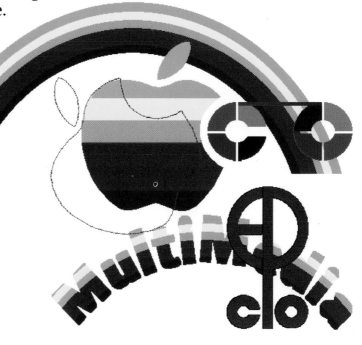

Ingredients
Graphics
1 Apple
1 Rainbow
1 Multimedia
1 Tapespool
1 EPCo logo
2 Company Labels
Text
1 Strapline
Sounds
1 roll (2 fluid seconds)
1 rewind and stop

Preparation

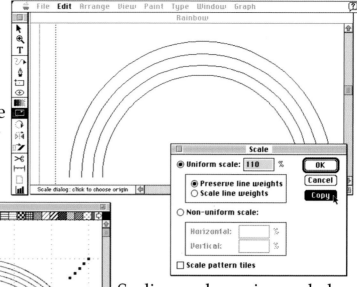

1 The Rainbow:
could be created in a
number of drawing
programmes but for the
sake of this exercise we
will look at MacDraw
and Adobe Illustrator.

Scaling and copying scaled
circles in Illustrator, or
drawing circles on a suitable
grid in MacDraw, will give a
suitable PICT for importing
into MacroMedia's Director.

2 The Apple: taken (with permission) from a compact disk of slide
presentations. Copied to the scrapbook as a PICT image and pasted
twice into the "**Cast**" window

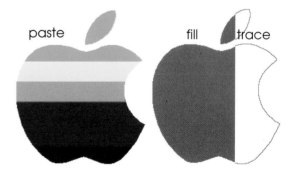

The second copy was then
filled in the Paint window with
a single colour and the
"**Trace Edges**" command
used to create an outline
for the animated version.

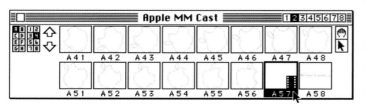

This outline was then
rotated in the Paint
window and a range of
cast members created at
different angles using
"**Auto Transform**".

29

3 MultiMedia graphic: Preparation of the word MultiMedia as a cut-out was one of the biggest challenges at the time this production was being created. The problem divided into two main areas: First, fitting the text to the curve and...

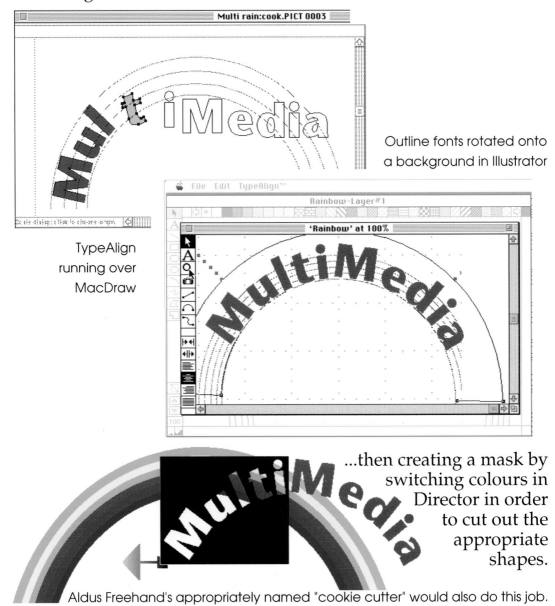

Outline fonts rotated onto a background in Illustrator

TypeAlign running over MacDraw

...then creating a mask by switching colours in Director in order to cut out the appropriate shapes.

Aldus Freehand's appropriately named "cookie cutter" would also do this job.

4 The roll sound: imported from MacroMedia's clip-sounds and the sound of the VCR shutting down recorded using MacRecorder, saved as a Sound Edit file before again being imported into Director.

Mixing

Once the cast elements had been prepared they were mixed in the score. Timing and transitions were then added.

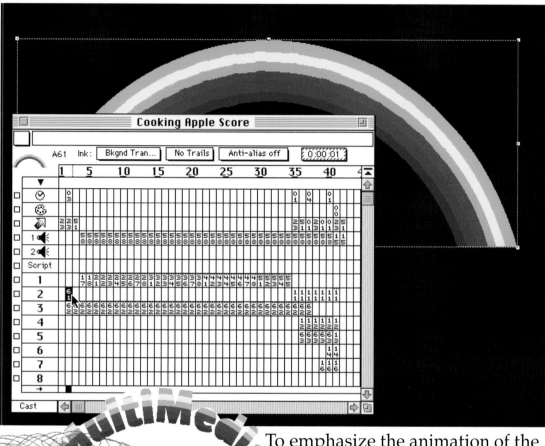

To emphasize the animation of the Apple a "**Trails**" setting was used, leaving the previous images on screen, and a black box then placed to hide them in frame 35.

The tape spools were given apparent animation using colour cycling on a limited palette and the clip closed with the sound of a tape recorder winding down and switching off.

Serving

The file was then recorded to tape using a TruVision "NuVista" Card.

Multimedia

There's nothing new about multimedia, the human race has used it since the first growl was reinforced with an animated shake of an appropriate limb to reinforce a message of displeasure.

Text began with hieroglyphics, when words were made of a thousand pictures.

Our language expresses it when we say colours shout.

What's *new* is that once we can convert the various media to a common format - digital - then we can combine them in the most effective manner and store and transmit the result easily and with no loss of quality.

In recent times, television has been recognised as a most powerful communications medium with its use of colour, animation, sound and text.

Client	Corporate - Irish Life
Type	Interactive Presentation
Colour	16 grey VGA
Delivery	Portable Computer
Length	30 minutes

P5

The Financial Project

An interactive brochure for use by Life Insurance consultants.

Mounted on a portable computer with a printer, the presentation
enables the user to display information
usually contained in printed brochures and
additionally perform premium and other calculations
on the spot, leaving hard copy with the client.

Links to a mainframe computer facilitate regular updating.

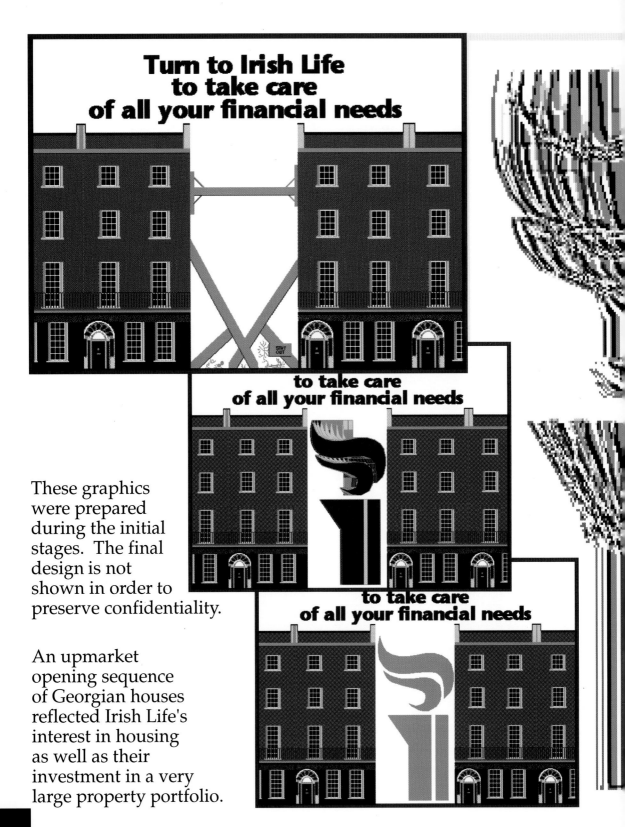

**Turn to Irish Life
to take care
of all your financial needs**

**to take care
of all your financial needs**

**to take care
of all your financial needs**

These graphics were prepared during the initial stages. The final design is not shown in order to preserve confidentiality.

An upmarket opening sequence of Georgian houses reflected Irish Life's interest in housing as well as their investment in a very large property portfolio.

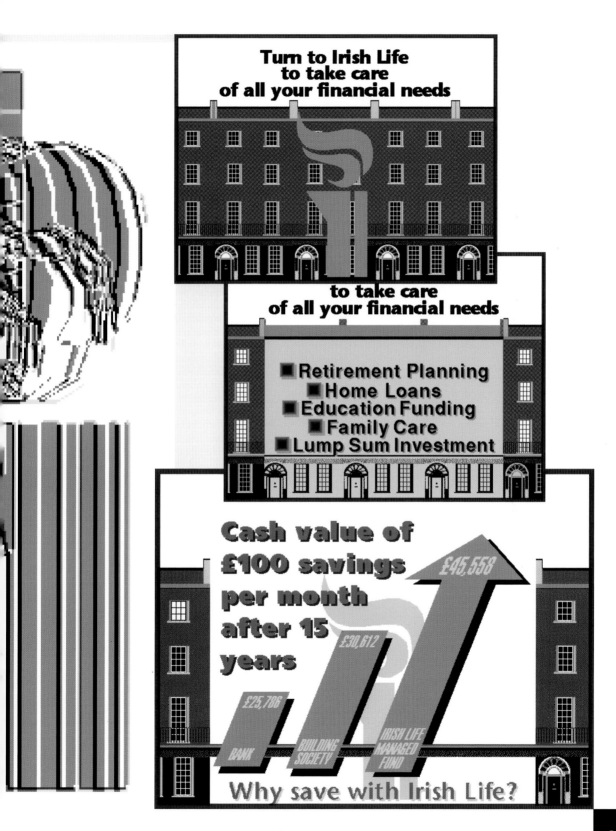

**Turn to Irish Life
to take care
of all your financial needs**

**to take care
of all your financial needs**

- Retirement Planning
- Home Loans
- Education Funding
- Family Care
- Lump Sum Investment

**Cash value of
£100 savings
per month
after 15
years**

£45,558

£30,612

£25,786

BANK

BUILDING SOCIETY

IRISH LIFE MANAGED FUND

Why save with Irish Life?

More is less

In computing, each day that passes seems to bring more for less.

More power for less money, and in a smaller casing too!

Portable computers can be used to deliver a video brochure.

Videographics is the child of digital technology and like its parent can deliver more information in less time than traditional video.

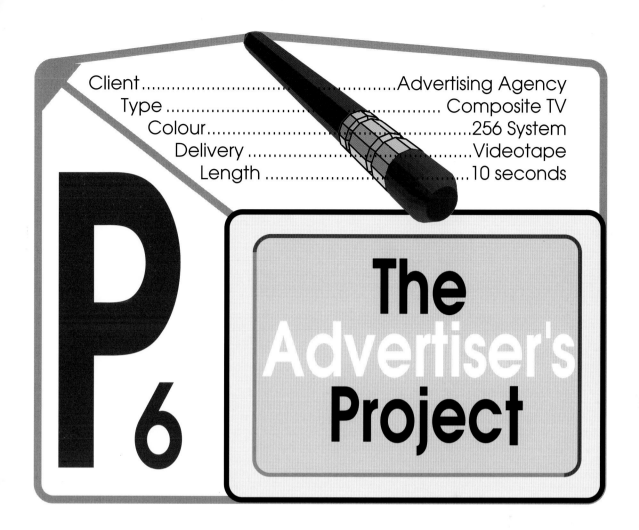

Client ...Advertising Agency
Type ... Composite TV
Colour...256 System
DeliveryVideotape
Length10 seconds

P₆ The Advertiser's Project

A design and production session set up
to make an instant production.

Actors, artists, director and client were assembled for
an afternoon in EPCo's studio and the final result
was produced in one session.

"If you have no vote.....you have no voiceand no say in how your country is governed.....

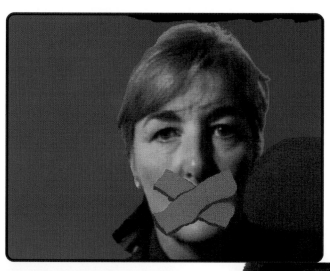

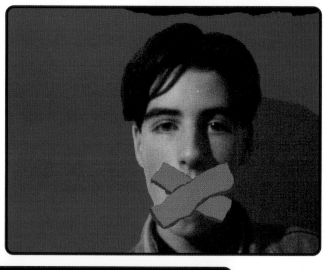

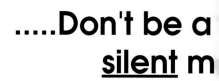

Department of the Environment
Register of Electors
20 Second TVC
No Voice

.....Don't be a <u>silent</u> m

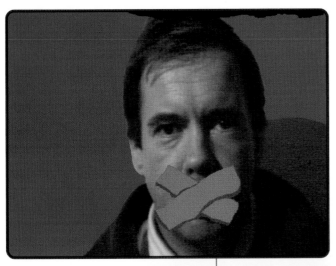

......to make sure <u>your</u> voice is heard, make sure <u>you're</u> on the register

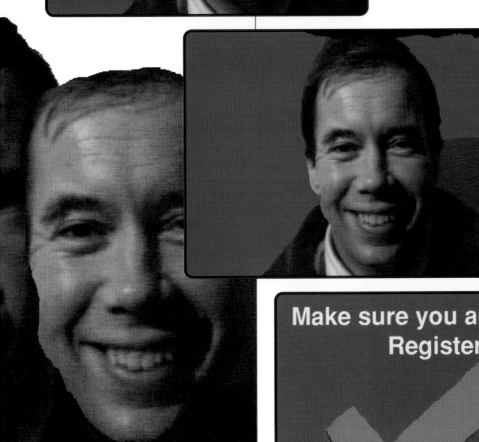

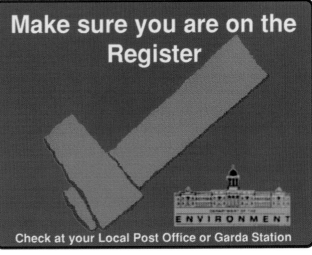

Make sure you are on the
Register

ENVIRONMENT

Check at your Local Post Office or Garda Station

ember of the
jority !!!"

39

Integrated Manufacture

Traditional industries tend to be fragmented-
often composed of many layers and diverse groups.

Both building and printing, where we have done much
of our work, are such, and in both design is separated
from the production process.

This leads to loss of control when production takes
over, or a failure in the final product where the
limitations of the production process are ignored.

In the computer age, actual production or the
simulation of it is back in the design studio.

The disciplines are still there but now we
have control: we can simulate and visualise
the final product on the computer screen.

This pencil is both design and product.

Sound

What is sound doing
in a book about design?
We are talking about design
on the small screen. If it is shown on a TV, there will be speakers
and many computers have or can be fitted with a sound capability.
It can be another element in the composition.

Research indicates that if an audience is shown two identical
sequences, one with sound and one without, their perception
will be that the one with
the sound track
has better graphics.

Client..Corporate - Apple
Type ...Continuous Display
Colour...256 System
Delivery..............................Computer Screens
Length ..5 minutes

P
₇

The Exhibition Project

Commissioned by Apple to demonstrate an
exhibition theme based on the concept
"The Apple Advantage".

Concept design by EPCo.
Certain graphics supplied by Apple Computer.

The brief required that a cycling demonstration of "Apple's Advantage" run on their current range of machines - all of which were on display- and also form the basis for an animated slide show to accompany a seminar presentation.

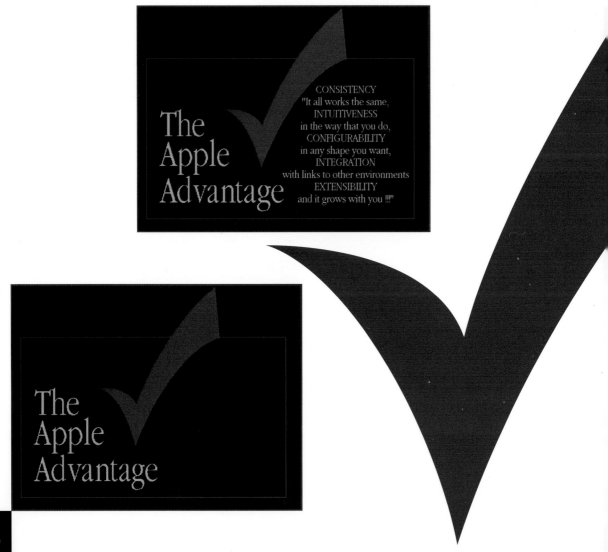

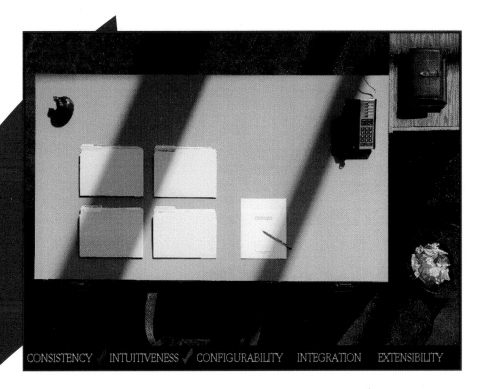

EPCo. designed the "Tick" which provided the graphic theme for Apple's stand and other exhibition material.

The photograph of the desk contains elements which fade to their equivalents on the Macintosh desktop

Enabling Technology

In an analogue world, the need to understand and control the means of production was often a factor which limited a designer to one area and inhibited the use of multiple media, however appropriate they might be.

The advent of digital technology frees the designer to cross barriers which have obstructed visual and aural links.
It is the glue which can stick a collage of graphics, sound, animations and video clips together.

At first the addition of another discipline - computing skills - was a further discouragement.
But the advent of the graphic-user friendly interface pioneered by Xerox and developed by Apple broke down the barriers and gave the designer access to the power of the computer.
Power without intelligence, it must be stressed - a most dangerous combination. Because a computer is only a calculator - words, graphics, sounds, are reduced to digits and processed ... fast.
But here lies the power of the tool for the designer. Not only can things be seen but they can be changed, viewed, reviewed, put away for future use, modified, tested, updated here and now, and later, for reusing and reworking, simulation and visualization.
A history, a library, a source book and your own clip art.
A dozen ideas explored where using traditional techniques there would only have been time for one or two.
The day that the "UNDO" command opens the door to exploration and "SAVE AS" files an idea for use in the future, then the real power is being harnessed.

Client..Area Health Board
Type ...Interactive Training
Colour...256 System
Delivery ..Computer
Length ...One hour

P8

The Health Project

A project exploring interactive computer-based training
for the mentally disadvantaged.

The objective was to provide self-paced training and in order to
encourage the students to use the course all the
photographic material and voice overs were
created on site by students and staff.

This resulted in a uniquely personal course and
may account for some of its success.

01010

The Health Board's logo was developed to create buttons which an animated figure pressed to bring appropriate photographs on screen. Once these were clicked, the individual's training areas were displayed and accessible.

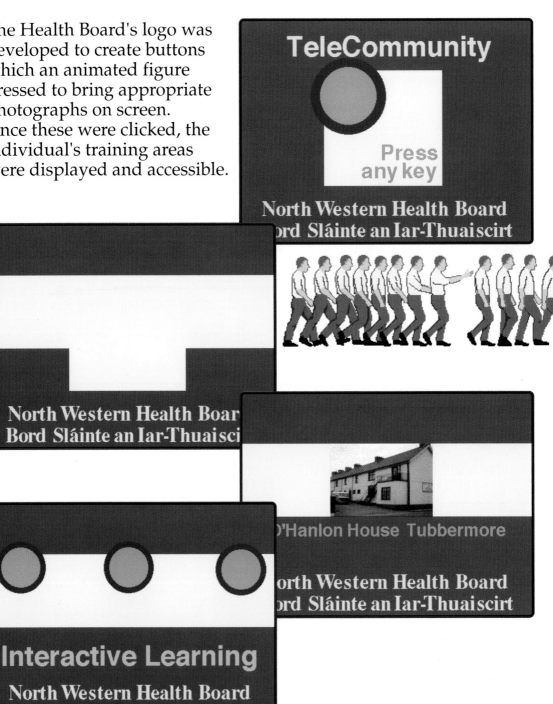

TeleCommunity

Press any key

North Western Health Board
Bord Sláinte an Iar-Thuaiscirt

North Western Health Boar
Bord Sláinte an Iar-Thuaisci

O'Hanlon House Tubbermore

North Western Health Board
Bord Sláinte an Iar-Thuaiscirt

Interactive Learning

North Western Health Board
Bord Sláinte an Iar-Thuaiscirt

Interactive Learning

North Western Health Board
Bord Sláinte an Iar-Thuaisci

Interactive Learning

North Western Health Board
rd Sláinte an Iar-Thuaiscirt

Interactive Learning

North Western Health Boar
Bord Sláinte an Iar-Thuaisci

animated figure

Now
click on
YOUR Picture

North Western Health Board
rd Sláinte an Iar-Thuaiscirt

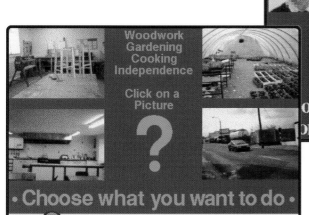

Woodwork
Gardening
Cooking
Independence

Click on a
Picture

?

• Choose what you want to do •

Go Back

faces have been obscured and
names changed to preserve
client confidentiality

The Quandary

We are reverse inventors.

We have some great solutions
and we're looking for suitable worthwhile problems.

In the years **BC** (Before Computers) if one had a problem
for example : crossing a lake
one invented a solution
for example : a boat.

In the years **AD** (After DOS) we have this extraordinary
multi-purpose tool which provides solutions to which
we may not even have problems.

To solve this one the PR industry invented Hype.

However, anything that offers the opportunity
of improving communications between people and
between people and machines cannot be too far out on a limb.

Since one of the main functions of communication is to pass on
experience, then teaching and training must be
appropriate areas in which to look
for suitable problems.

Client...Corporate - KLAS Ltd
Type ...Promotional
Colour..256 System
DeliveryComposite Video
Length20 minutes

P₉

The Promoter's Project

KLAS are a company involved in the implementation
of Integrated Service Digital Networking
and associated hardware and software.

Their potential clients are worldwide.

They required a video to promote the concept of ISDN
which could be distributed to interested parties
and easily updated to deal with
the rapidly changing technology of Telecoms.

01010

An optional opening sequence

The decision was taken to modularize the design, using a strong visual link capable of pulling all these pieces of information together.

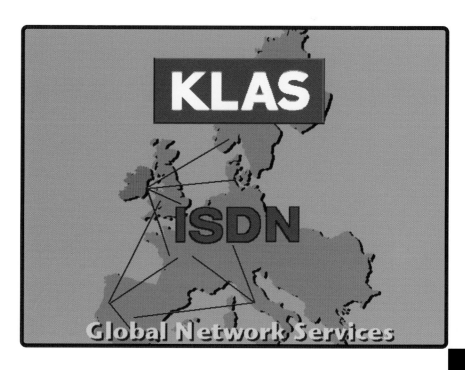

Integrated Services Digital Network

offers the Business User

•

Improved Quality

•

Reduced Costs

•

Range of New Services

Each section of the video was designed to be independent of the others and capable of being issued or updated independently.

The clapperboard was used to link and identify the different sections.

KLAS

ISDN

Global Network Services

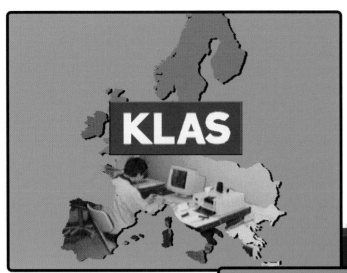

Simulation is one of the great strengths of videographics.

The software interface shown here was still in the early stages of design.

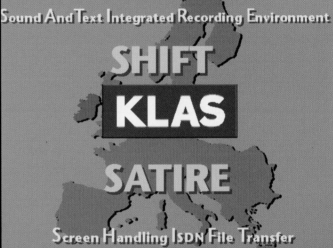

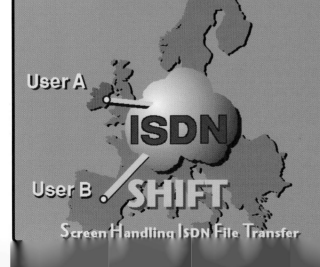

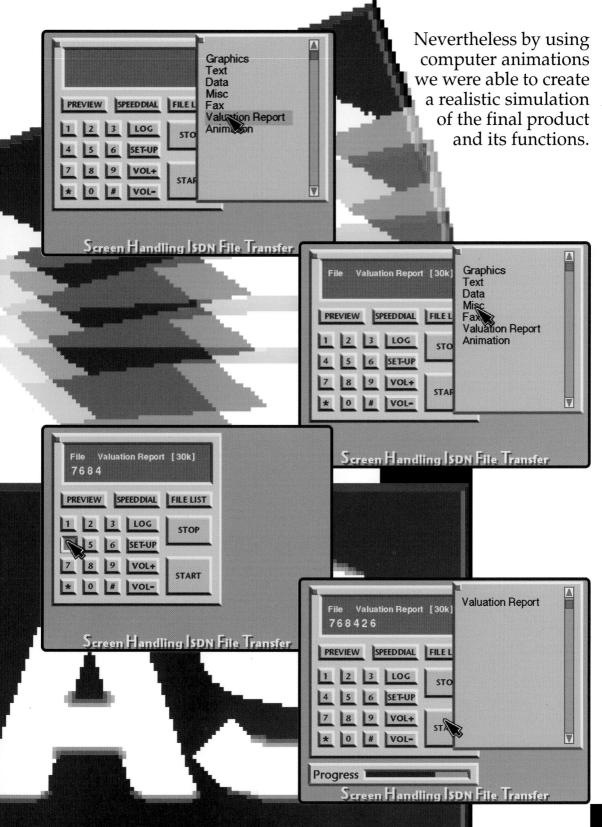

Nevertheless by using computer animations we were able to create a realistic simulation of the final product and its functions.

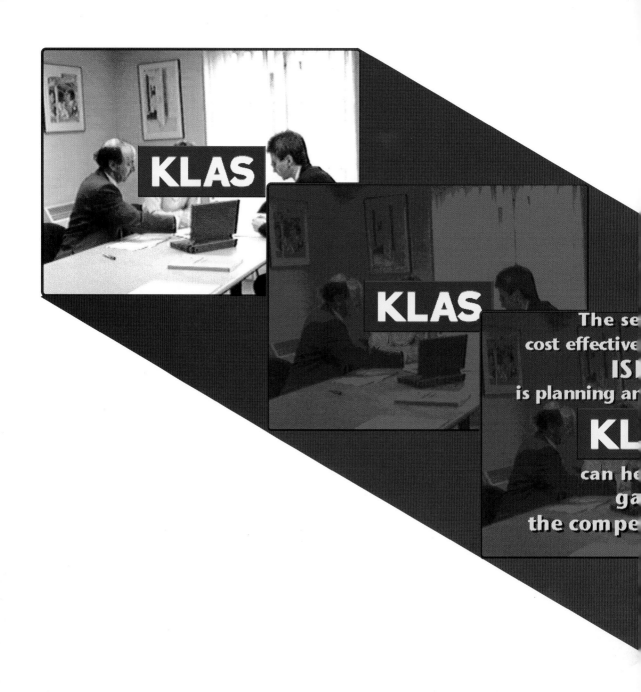

Later sections use video grabs from
tapes shot on the premises, showing
company directors and personnel
with whom clients will be familiar.

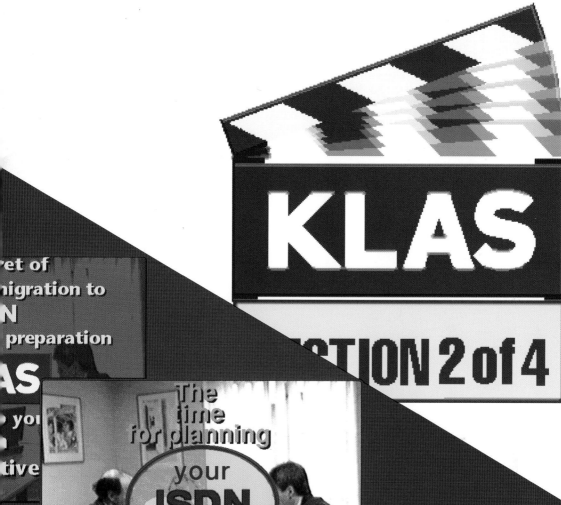

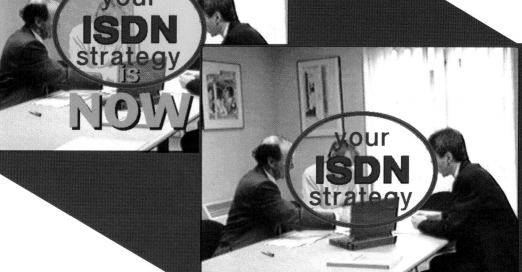

Closing sequences use the wall to write final messages and a
Company Poster with a corner that peels to close the video....

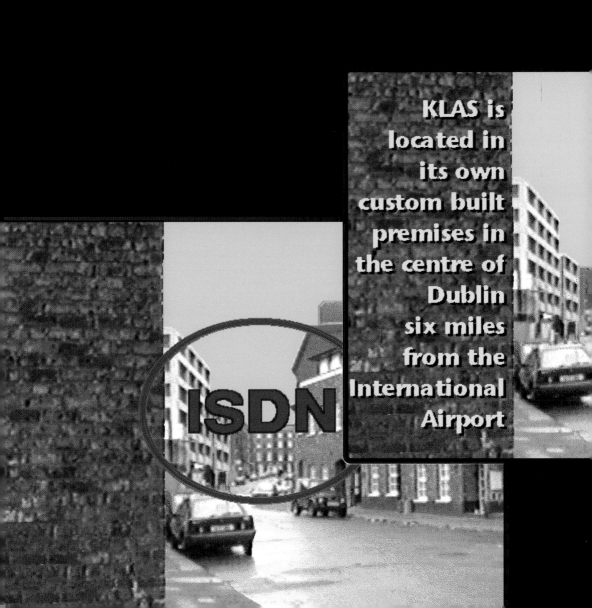

KLAS is
located in
its own
custom built
premises in
the centre of
Dublin
six miles
from the
International
Airport

ISDN

Comparisons with Traditional Video

Traditional video as produced for the television screen usually reflects its origin as a medium designed to be broadcast to a mass audience, assumed to be only broadly aware of the subject matter. This is reflected in its visual form and, because it is based on continuous movement, design is more concerned with the composition of the visual flow rather than the graphic composition of each individual frame.
The broad sequence in making a point is to set up the shot, make the point and then move out and on.
Traditional video is better at dealing with its subject in an emotive way and making an appeal to the heart.

Videographic productions , in contrast, are usually commissioned to address a specific audience who are interested in, and probably aware of, the subject matter.
They tend to deal with facts and to appeal to the mind.
Videographic productions are therefore capable of being much sharper and far more concise.

In our experience to date commissions to convert a traditional video to a videographic sequence have resulted in a reduction of at least 50 per cent in running time while covering the same subject matter.

Huge technical effort is being made to achieve Full Motion Video on screen and when this is achieved it will revolutionize the TV production industry in the same way that desktop publishing evolved and is changing the printing industry.
Our industry is in danger of ignoring a whole new art form developing under its nose.

The art of still graphics is not just a stop on the way -
it is a journey and an end in itself.

Client ...State Agency
Type ...Interactive Presentation
Colour...256 System
DeliveryPortable Computer
Length20 minutes

P₁₀ The Presenter's Project

This Project was commissioned by a state-funded agency whose Marketing Manager represents a number of companies, some or all of whose services might be of interest to his audience.

Since he could not be aware which services might be appropriate for his ever-changing audiences, EPCo. created a fully interactive structure enabling him to roam at will through his presentation.

The work is capable of being continually updated.

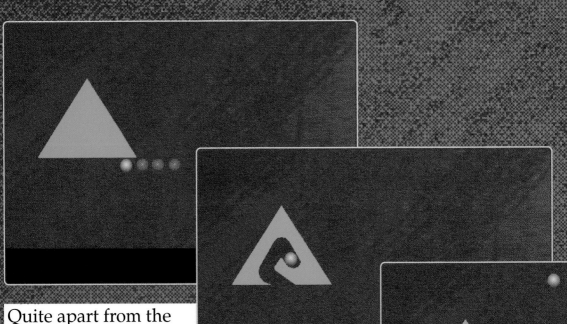

In
pr
"H
us
ca
up

Ar
en

Quite apart from the
need to have all
sections of the
information instantly
available, it was also
a requirement that the form of presentation
be hi-tech since the firms represented are
leading-edge manufacturing consultants.

An opening animation was therefore
devised which carved out the form of the
logo to the sound of a machine router.
By the time this finished the audience were
fully attentive.

Workshops

Familiarisation with Concepts
Manufacturing Problem Identification
Benchmarking
Action Recommendations
Implementation

Training

Short Courses

Long Courses

Inhouse Courses

der to achieve full interactivity the
ntation is driven from an Apple PowerBook.
' screen areas, buttons and text were linked
; Lingo scripts and the whole structure
ully planned to allow expansion and
ting, including QuickTime movies.

mergency button exists on all screens which
es the presenter to return to the initial frames.

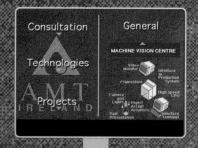

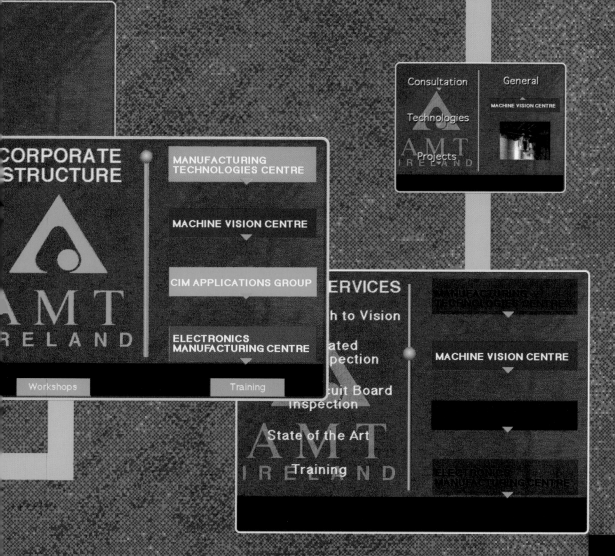

Flexibility

Unless you are very sure that a project is once-off and finished, bear in mind that the technology will allow expansion, updating and re-use - a modular approach is often useful in retrospect.

Dealing with change

Flexibility is the key to survival in a fast moving world.
Its not the rate of change.
It is the rate of change of the rate of change that must concern us.

Anything that enables us to update and/or review our designs easily must be useful.

Survival and adaptability have a historic link.

Client ..State Agency
TypeInteractive Public Information
Colour..256 System
Delivery ...Computer
LengthContinuous

P 11

The Environment Project

A front end for a Macintosh Public Information System in the Department of the Environment.

Designed to invite users to explore the information and Eco-Games on the machine while defeating schoolboy hackers who regularly raided the previous system.

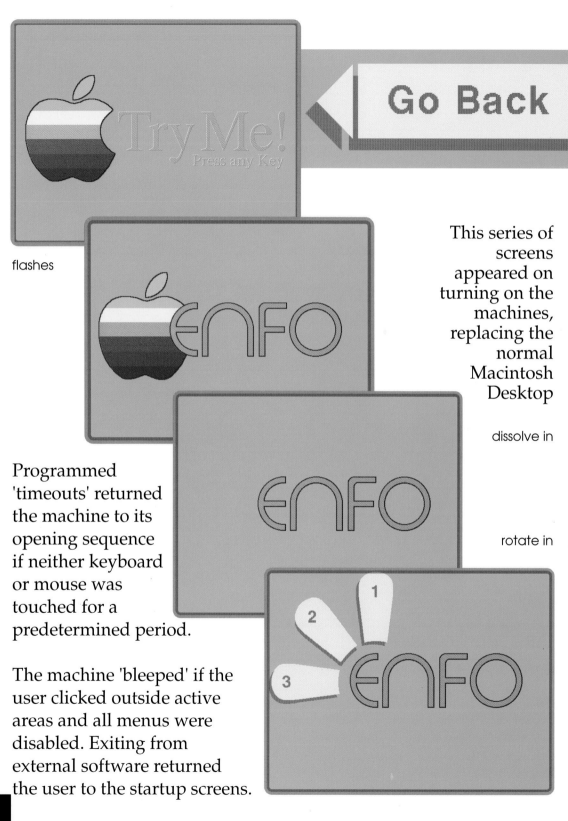

Go Back

flashes

This series of screens appeared on turning on the machines, replacing the normal Macintosh Desktop

dissolve in

rotate in

Programmed 'timeouts' returned the machine to its opening sequence if neither keyboard or mouse was touched for a predetermined period.

The machine 'bleeped' if the user clicked outside active areas and all menus were disabled. Exiting from external software returned the user to the startup screens.

Go On

arrows highlight on mouseclick

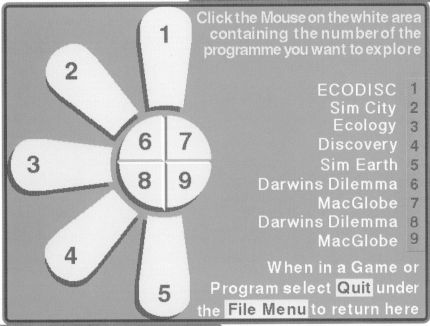

Click the Mouse on the white area
containing the number of the
programme you want to explore

ECODISC	1
Sim City	2
Ecology	3
Discovery	4
Sim Earth	5
Darwins Dilemma	6
MacGlobe	7
Darwins Dilemma	8
MacGlobe	9

When in a Game or
Program select Quit under
the File Menu to return here

animate text elements in

The design has been extended
by adding additional
buttons in the centre
to access the results of
environmental surveys.

Interactive Interfaces

The man/machine interface has had volumes written about it but in essence the user must feel that **they** are in control.

The interface should therefore be responsive, consistent and build on skills they already have rather than requiring new ones.
It should also provide feedback to user actions wherever possible.

Some basic rules

Don't lead the user up a cul-de-sac.

Provide a clear structure and a map if appropriate.

Buttons should react immediately and remember that an escape or undo button is useful.

Never leave the user with nothing happening - they will probably think something's broken!
Use a message such as "please wait a moment".

The button back out should be in the same place as the button that got the user in.

Use a bleep or similar message for non-interactive areas.

Client ...Corporate - TRINTECH Ltd
Type ..Point of Information
Colour...256 System
Delivery ..Videotape
LengthContinuous

The Demonstration Project

Commissioned as part of a marketing drive to sell
card swipe machines across Europe.

Designs included simple presentations,
personalized presentations to banks and potential investors
and continuous displays for exhibitions.

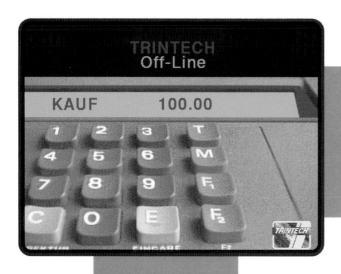

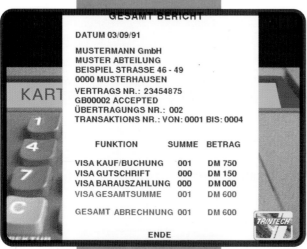

The final files were linked using Lingo scripts and then recorded onto VHS tape in PAL format using a TruVision NuVista card and an Encoder/Decoder to convert the Mac RGB signal to composite video.

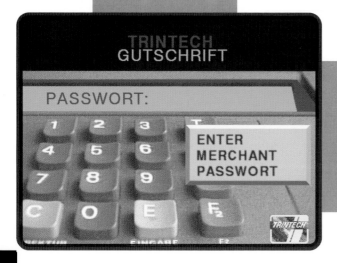

This was played as a continuous information sequence at the Hanover CEBIT Exhibition to explain the sequence of entering, verifying, transmitting and updating information.

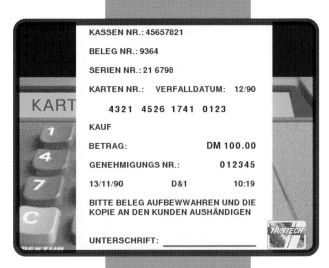

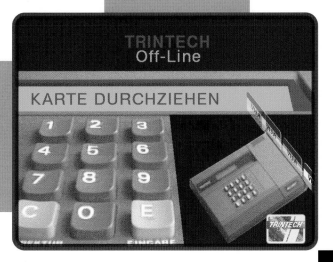

71

A video shot of the card swipe machine, composed of three layers combined in Director to overcome depth of focus problems.

The small LED screen was enlarged to provide more space for text - particularly in the German version.

Key strokes were animated using the layering technique developed for the "No Voice" Project. (pp 37-40)

The design allowed for multiple language versions and the graphics were designed to form part of service videos and interactive training programmes for operatives.

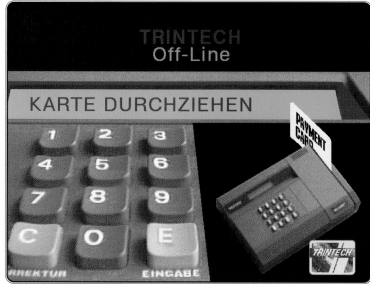

An inserted animation was used to show the method and direction of "swiping" the plastic card.

profile of 'click' sound

layering of components for
animated card sequence

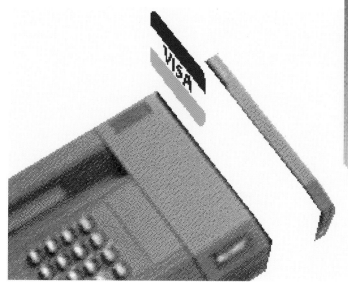

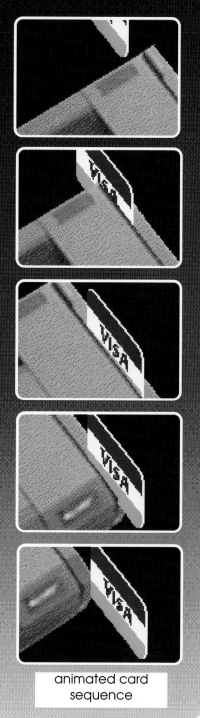

animated card
sequence

Restraint

The biggest problem for the tyro desktop publisher was that it was all too easy.

With all that power - dozens of fonts, in hundreds of point sizes - each one in several styles - it was easier to get it wrong than to get it right.

"Restraint" was our design advice.

Now we have 256 or maybe millions of colours, sound, animation and hundreds of graphic effects.

Take the advice and double it.

Power

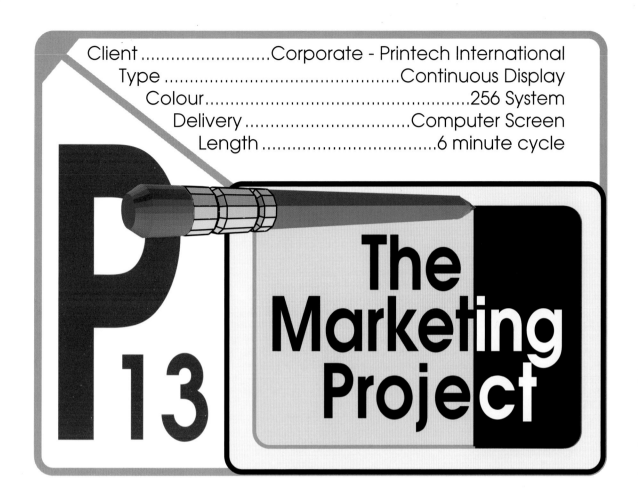

ClientCorporate - Printech International
Type ...Continuous Display
Colour...256 System
DeliveryComputer Screen
Length6 minute cycle

P13

The Marketing Project

A continuous running Macintosh based display for the
Comdex Fall Exhibition in the United States.

Animation and sound were used to attract the attention of visitors.

The presentation was then extended to include QuickTime clips
to provide a state-of-the-art show for the
spring CeBIT Exhibition in Germany.

01010

Acting as attention grabber, the globe in Printech's logo is bounced in at the start of the cycle and as each aspect of the company service is ticked off it is accompanied by a melodious chime.

Client company logos were used since they are instantly recognizable.

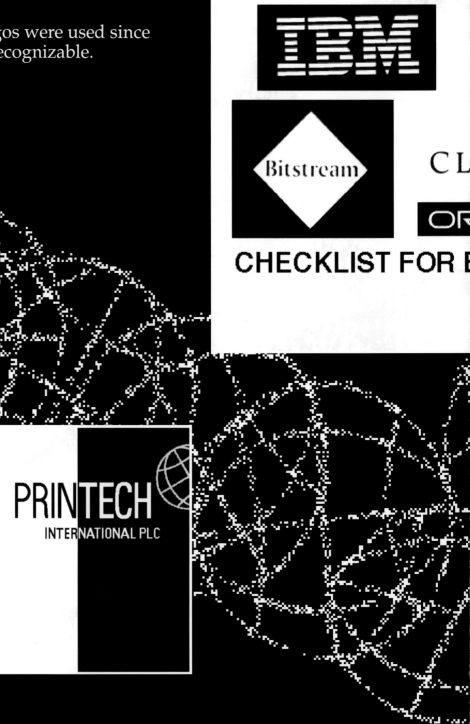

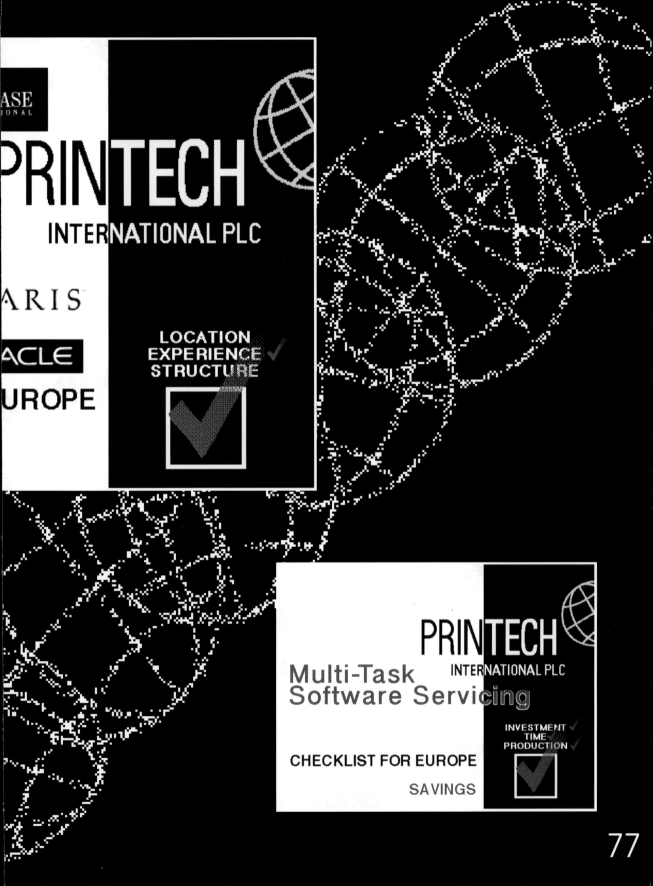

PRINTECH
INTERNATIONAL PLC

ARIS

ACLE

UROPE

LOCATION
EXPERIENCE
STRUCTURE

PRINTECH
INTERNATIONAL PLC

Multi-Task
Software Servicing

INVESTMENT
TIME
PRODUCTION

CHECKLIST FOR EUROPE

SAVINGS

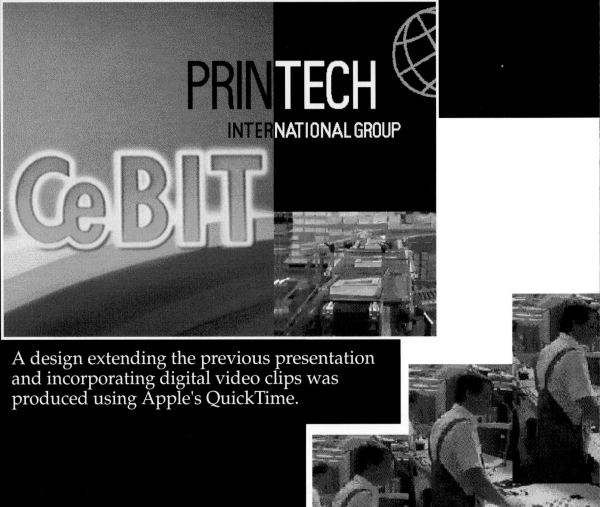

PRINTECH
INTERNATIONAL GROUP

CeBIT

A design extending the previous presentation and incorporating digital video clips was produced using Apple's QuickTime.

The resolution of the video windows was kept at 256 colours to allow them to play without hardware support on a Macintosh CX. Since the windows were deliberately treated as graphic elements within the design the final effect was more than acceptable. The print resolution of the video grabs is not representative.

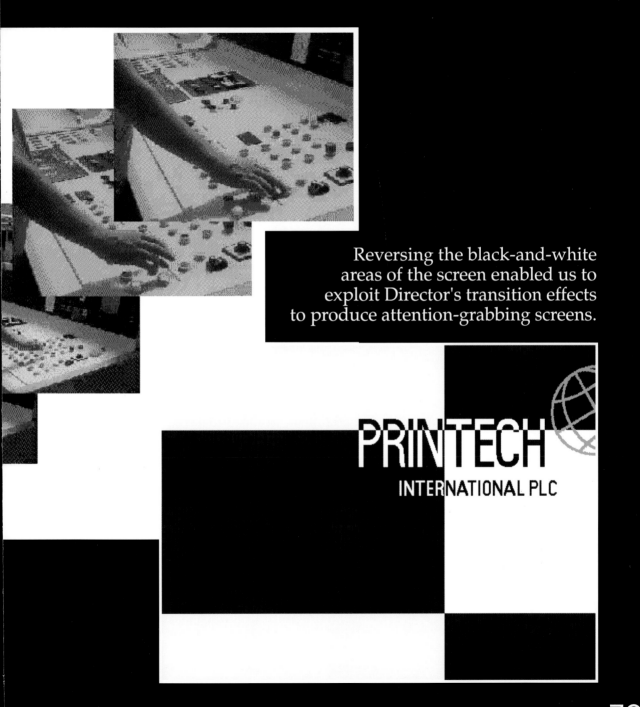

Reversing the black-and-white
areas of the screen enabled us to
exploit Director's transition effects
to produce attention-grabbing screens.

PRINTECH
INTERNATIONAL PLC

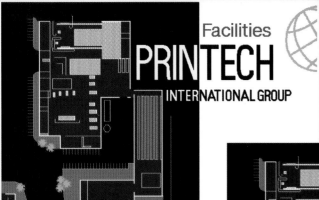

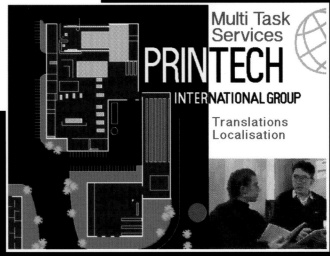

A plan of the complex was created to identify the locations and to describe the activities where the short video clips were recorded.

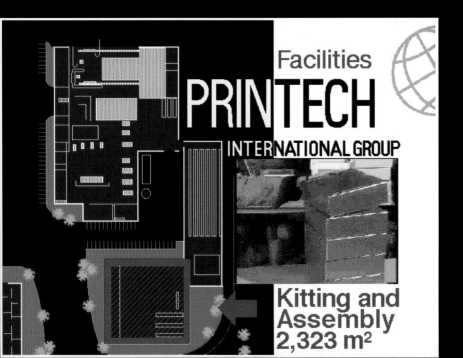

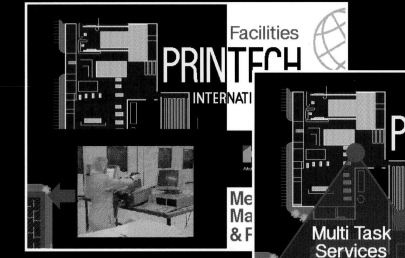

Facilities

PRINTECH
INTERNATIONAL GROUP

Me
Ma
& F

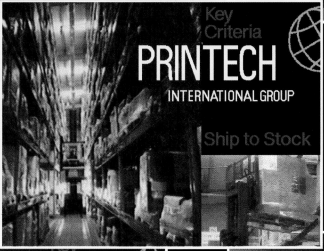

Multi Task
Services

PRINTECH
INTERNATIONAL GROUP

Translations
Localisation
Media Duplication
Printing
Finishing
Kitting
Assembly
Warehousing
Distribution

Multi Task
Services

Key
Criteria

PRINTECH
INTERNATIONAL GROUP

Ship to Stock

Text and
graphics
used in
conjunction
with the
digital clips
reinforced
the video
messages.

Criteria

PRINTECH
INTERNATIONAL GROUP

Reinvestment
■ Investment
IR£24,000,000
over ten years

'92

Key
Criteria

PRINTECH
INTERNATIONAL GROUP

People

Screen Limitations

The limitations of the screen proportions cannot be ignored.

Whilst the size is variable, a ratio of 4:3 is the norm for both computer and video, so if you want something different all you can do is cheat.

Using black lines or panels to link up with the screen surround can change the apparent proportions.

Black horizontal bands to extend the boundaries can alter the screen's apparent shape.

The wide screen seen at the end of many films shown on TV, in order not to distort the credits, says "end of show" and can be used accordingly.

ClientCorporate - Bank of Ireland
Type ...Point of Information
Colour...256 System
Delivery ...Computer
LengthContinuous

P14

The Banker's Project

Originally commissioned as a continuous display
in the lobby of the bank's Technology Centre.

Developed to be an interactive point of information,
maintained and updated by the client.

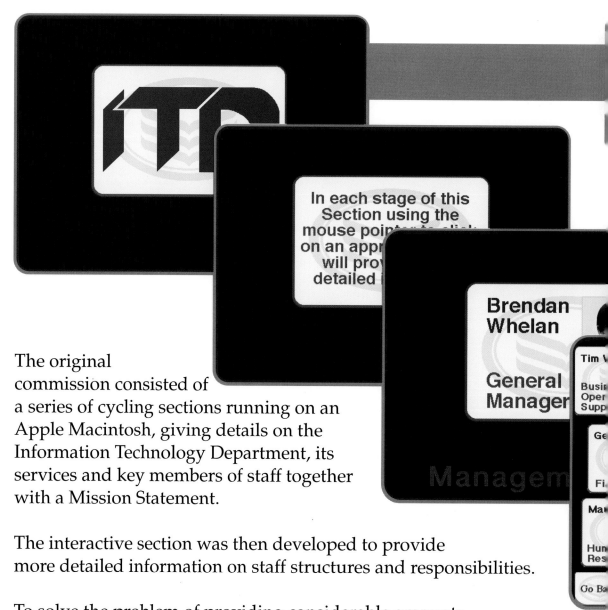

The original
commission consisted of
a series of cycling sections running on an
Apple Macintosh, giving details on the
Information Technology Department, its
services and key members of staff together
with a Mission Statement.

The interactive section was then developed to provide
more detailed information on staff structures and responsibilities.

To solve the problem of providing considerable amounts
of information on large departments, the development of an
"Identity Card" button proved a very useful graphic device.

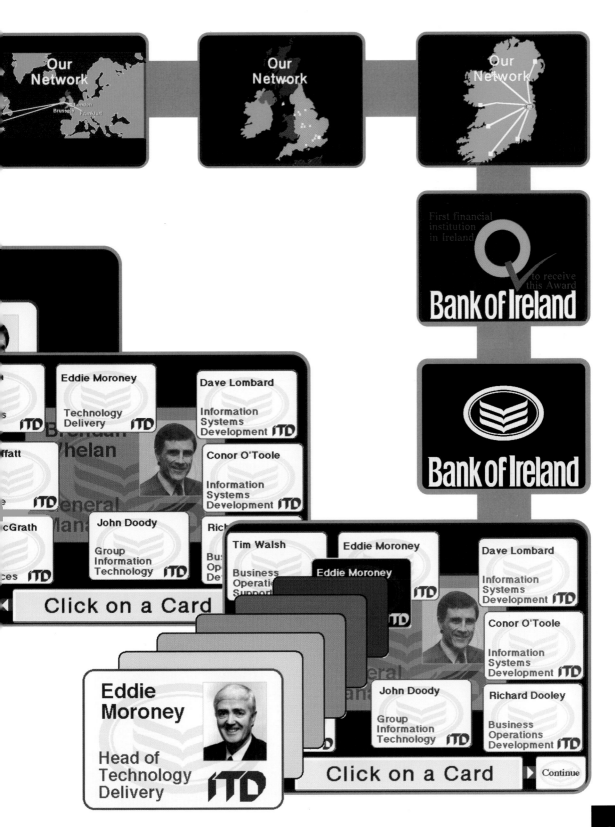

Our Network

Our Network

Our Network

First financial institution in Ireland
to receive this Award

Bank of Ireland

Bank of Ireland

Eddie Moroney
Technology Delivery
ITD

Dave Lombard
Information Systems Development
ITD

Conor O'Toole
Information Systems Development
ITD

John Doody
Group Information Technology
ITD

Click on a Card

Tim Walsh
Business Operations Support

Eddie Moroney
Eddie Moroney
ITD

Dave Lombard
Information Systems Development
ITD

Conor O'Toole
Information Systems Development
ITD

John Doody
Group Information Technology
ITD

Richard Dooley
Business Operations Development
ITD

Click on a Card
Continue

Eddie Moroney
Head of Technology Delivery
ITD

Text

People do not read accurately from screen.

Text should be short, snappy and to the point
 - copywriting skills will not come amiss.

The old slide rule of around,
 six lines per slide
and
 six words per line
should not be ignored.

Don't forget that text can be also be used graphically,
providing you do not lose the message:

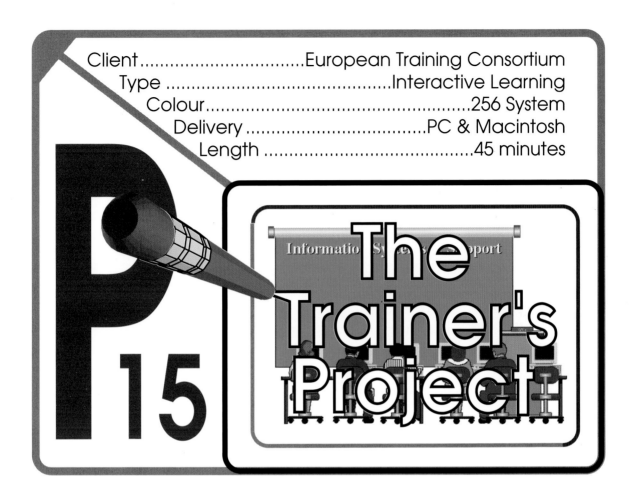

Client................................European Training Consortium
Type ...Interactive Learning
Colour...256 System
DeliveryPC & Macintosh
Length45 minutes

The Trainer's Project

Information Systems Support

A European Project
for interactive computer-based training
in several modules.

Produced with the financial support of the Commission of European Communities
under the FORCE Programme

01010

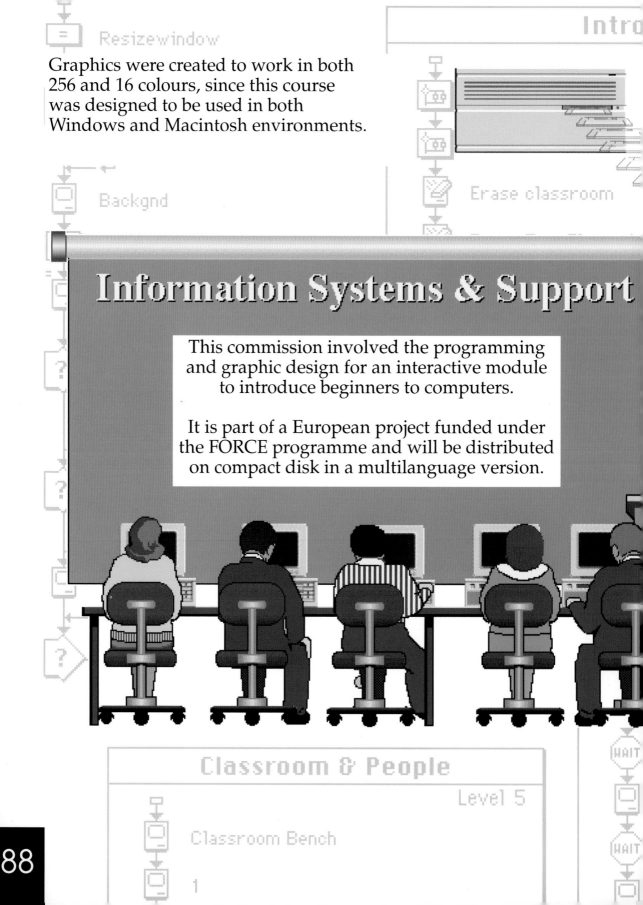

Graphics were created to work in both 256 and 16 colours, since this course was designed to be used in both Windows and Macintosh environments.

Information Systems & Support

This commission involved the programming and graphic design for an interactive module to introduce beginners to computers.

It is part of a European project funded under the FORCE programme and will be distributed on compact disk in a multilanguage version.

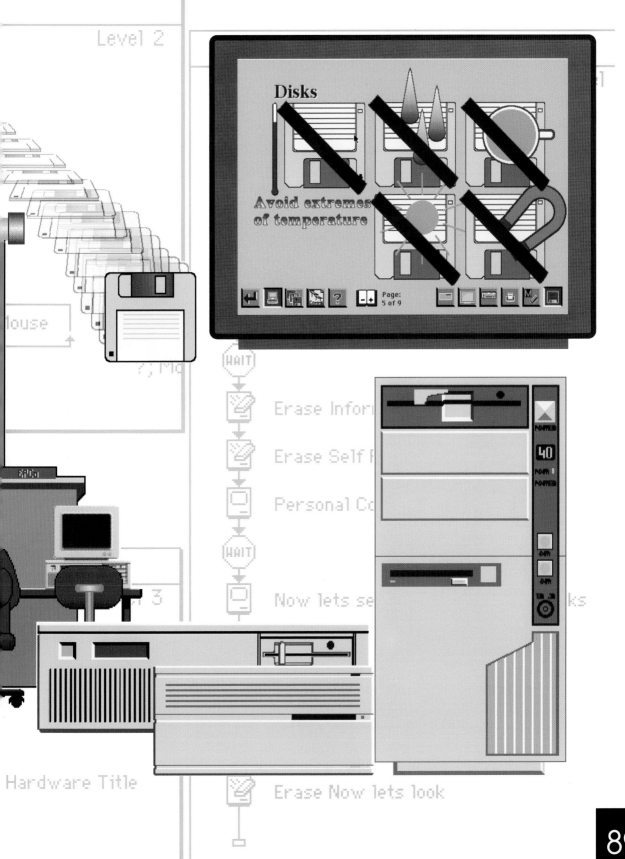

Sketch Designs

WYSIWYG (what you see is what you get) is great because it presents you with a clear representation of the finished work.

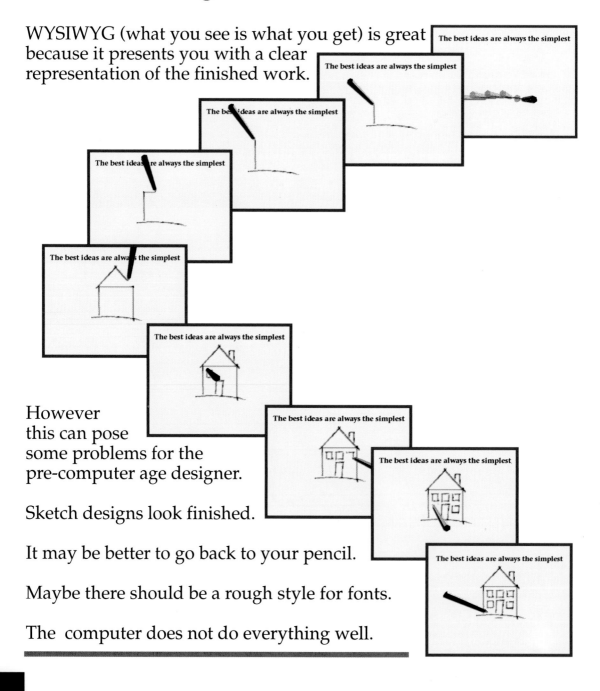

However this can pose some problems for the pre-computer age designer.

Sketch designs look finished.

It may be better to go back to your pencil.

Maybe there should be a rough style for fonts.

The computer does not do everything well.

Projects represented
include proposals
and work for
the following
companies :

Apple
Bailey's
Canon
Johnson Brothers
Cable Management

P₁₆ Miscellanea

It's fun too -

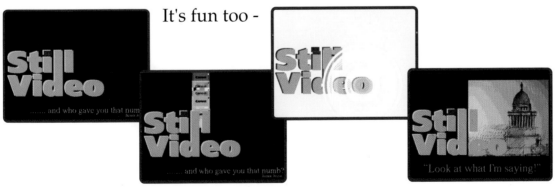

In this exercise the elements of the text represented the disk-based camera. The red dot on the "**i**" of the word "**Still**" was the shutter button and the flash simulated from the "**o**" with light and sound.

Backgrounds can add
depth, set a style or
simply enrich a
presentation:

Soft dark silk
for a dark coffee
liqueur sold in Australia.

Obscured glass/
beach pebbles/
fresh colours
for selling
hygiene,
cleansing and
toilet
products.

Linen for a
presentation
in New York.

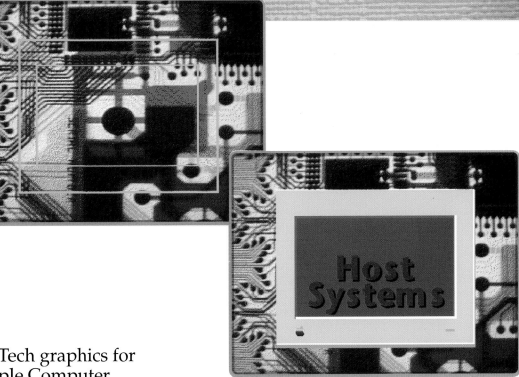

Hi Tech graphics for
Apple Computer.

Specialization

The age of the specialist is dying.
Specialization is fragmentation.
When fragmentation goes, a holistic approach becomes possible.
When media is mixed digitally, integration becomes possible.

When technologies converge, great new things can emerge.
The power of TV plus the processing power of a computer.

Design Trends

Graphic design in the computer age begins to reflect
the breakdown of the boundaries between the various visual media.

The growth of the
"New Wave" layered style
of Graphic design in the 70's
in California was probably the
first sign of an implosion of styles.

A holistic approach is coming back into fashion.

Index

This book is about Ideas.
Some are in the text.
Most in the graphics.
Read, look and enjoy.

Graphics page

Text